SECRET WOKINGHAM

Richard Gibbs

AMBERLEY

About the Author

Richard's books reflect his broad interests from local history to long-distance walks. Following a successful career in business, he has moved into academia and teaching. He has appeared on radio and gives talks and presentations on various themes.

First published 2023

Amberley Publishing
The Hill, Stroud
Gloucestershire, GL5 4EP

www.amberley-books.com

Copyright © Richard Gibbs, 2023

The right of Richard Gibbs to be identified as the Author of this work has been asserted in accordance with the Copyrights, Designs and Patents Act 1988.

ISBN 978 1 3981 0400 6 (print)
ISBN 978 1 3981 0401 3 (ebook)

British Library Cataloguing in Publication Data.
A catalogue record for this book is available from the British Library.

Origination by Amberley Publishing.
Printed in Great Britain.

Contents

Preface

'*Lector, si monumentum requires, circumspice.*'
'Reader, if you seek his monument, look around you.'
Carved on the tomb of Sir Christopher Wren in
St Paul's Cathedral.

It would not be too much of a liberty to paraphrase the above quotation by saying 'If you seek the history of Wokingham, then look around you.' Secret Wokingham lies to be discovered by those who open their eyes. Much of the town's history is hidden in plain view. If we know where to look, and what we're looking for, the story of the town can be uncovered by walking around.

The oldest history of the town, its early foundation and establishment can be 'seen' in several ways.

The name Wokingham gives us a firm clue to the founding of the town. Sometime around AD 750, an Anglo-Saxon tribe ruled the surrounding area. Their main settlement was at Woking, and they were called the Woccingas after their leader Wocca. As the tribe expanded, members left the main village to set up new communities at Woking-ham and Woke-field. Wokefield, like Shinfield and Arborfield, gives an indication that the area was suitable for planting and growing crops.

But why then was the precise location of Wokingham chosen?

The Emm Brook is a small river that flows to the west of the town. It is not navigable and probably never has been. It would have been attractive to small game, which could have been hunted, and, of course, it would have provided a water supply for the inhabitants of the embryonic town. Having said that, there are reputedly several hundred wells in and around Wokingham.

The town is around 75 metres above sea level, which makes it approximately 30 metres higher than the surrounding area. It would probably have been drier due to its elevation, and being sited on gravel, the nascent town would have been less prone to flooding and cold dampness.

Wokingham sits on what was the border between two distinct kinds of landscapes and environments, one providing timber, the other providing pasture for cattle. The town was situated on the edge of a vast forest that we now know as Windsor Great Park. As the forest petered out, the countryside to the west of the town would have become more open heathland as reflected in the name East-Heath. We can speculate that the choice of location was, consequently, not random but deliberate. The site would have provided numerous benefits to the earliest inhabitants.

The history of the town's foundation can, therefore, be uncovered through its name and the topography and geography of the area. The town's 'secret history' from its Anglo-Saxon past, through the medieval period, the Victorian era, and today can be similarly uncovered with a little bit of detective work and observation.

Richard Gibbs
Finchampstead

Starting Point

'Among the little hamlets with which Windsor Forest in olden time was thinly studded
was one of larger dimension, and of more important character than the others.'
London Illustrated News, 23 June 1860, on the opening of
Wokingham's new Town Hall.

There are many locations and dates which could be the starting point for a secret history
of Wokingham.

But I am going to start pretty much in the centre of the town, in what is currently
a supermarket car park. At the south-western edge of the car park is the garden of
Montague House. In the garden is an Oriental plane tree. Its precise antiquity is not
known, but expert opinion dates it to the middle of the eighteenth century, which would
make it around 250 years old. The tree would have been a sapling before the American
War of Independence in 1776, when George II was on the throne and Wokingham had a
population of fewer than two thousand souls. To put that in perspective, the population
of England at the time was around 6 million. There are other veteran trees in town, such
as the beautiful 300-year-old oaks nearby in Milton Road, and although Oriental plane
is neither the oldest nor officially the center of the town, it represents in many ways the
heart of the town.

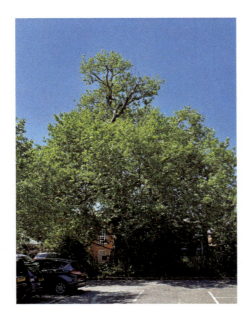

Oriental plane tree in the garden of
Montague House.

The 'Medieval' Town

From this central location, it is possible to explore the town and seek out its secret past. On the corner of Milton Road and Broad Street is Tudor House. This is a Grade II* listed building. The name is not a misnomer as the house does originate from the Tudor period of Henry VIII and Elizabeth I, and it dates from some time in the 1550s. With its exposed timber frame, painted render, and stucco infill, Tudor House seems to overlook Broad Street and matches the elegance of the later Montague House on one side and The Elms on the other.

At one time, Tudor House would have been only a short distance away from a late medieval house. This was probably incorporated into a substantial rebuild in or before 1624, which was in turn subsumed into a new building. It was this building that was converted to Beeches Manor Hotel and which burnt down in 1961. Beaches or Beeches Manor was around the corner from Norreys Manor, which is mentioned in documents dated 1443. And then on the outskirts of town, there is Cantley Manor and Buckhurst (St Anne's) Manor, Ashridge Manor dating to 1281, and Evendons from the fourteenth century.

Sixteenth-century Tudor House.

The Beeches Manor Hotel.

It is, therefore, possible to think of Wokingham as comprising several manors with big houses which were owned over the decades and centuries by a number of notable families, including the Nevilles, the de la Beches and the Whitlockes. The legacy of these manors and families are all around us in the structure and layout of the town, as well as in place names and street names.

The former Beeches Manor stood roughly where the nursing home of the same name stands today. The dower house of a manor was where the widow of the lord of the manor lived; the dower house to Beeches Manor remains today as the administrative offices of the Holt School. The original owners of the Manor estate from the thirteenth century are understood to have been the de la Beches. Roger de la Beche rented land from the Bishop of Salisbury. Roger died in 1297, leaving 500 acres to his son Geoffrey. Possibly as early as 1454 the Whitlockes took over the Beeches Manor, the Holt and various other outbuildings, cottages and meadows. In the seventeenth century, the manor house was the home to Richard Hawe. He was a brewer. After Hawe, William Yelldall rented the house; he was also a brewer. And then came the Webbs, who were brewers too. And subsequently, in 1851, the Haywoods moved in, and, you've guessed it, they were brewers. And as a reminder of this long history with the brewing trade, the malt house at Beeches Manor still exists today on the Reading Road and serves as the Masonic Lodge. During the First World War, the malt house was used as army quarters for soldiers who were on their way to France. In the Second World War, American GIs were quartered in the

Rose Street looking towards Broad Street, around 1890.

building before going overseas to Normandy. It was after the war, in 1946, that the Freemasons purchased the building.

The oldest street in Wokingham is probably Rose Street. This street was originally called Le Rothe Strete, and this can be interpreted from the Anglo-Saxon as meaning 'the clearing in the woods'. This name would appear to be very appropriate, as the area was probably wooded, and a clearing would be where the hamlet's earliest inhabitants would have lived. Its proximity to All Saints Church is of course highly relevant as we know that a church has stood here since at least 1190, when it was dedicated by Hubert, Bishop of Salisbury. And so, if you step out of the church today and walk down Rose Street, you are most likely following in the footsteps of some of Wokingham's first citizens.

Rose Street was a medieval closed street. This means that both ends were effectively blocked off by buildings, allowing only a relatively narrow entrance for people and carts. The Wiltshire Road end retains this structure, although the Broad Street end was changed in the last century to offer better access to vehicles. The first of these two photographs show Rose Street in about 1890, looking towards Wingmore Lodge. The road has not yet been tarmacked, and one can wonder at how muddy it would become in the wet, especially with the horses and carts. In the second photograph, taken around 1910, and towards the Wiltshire Road end, the asphalt road has been lain, and we could

Rose Street around 1910.

No. 15 The Terrace, an early fourteenth-century house.

The Terrace, *c.* 1860, earliest known photograph of Wokingham.

Reading Road looking east by The Terrace around 1910.

expect to see a car or two, although in this early photograph a horse or hand-drawn cart is parked up.

The oldest house in Wokingham is generally considered to be No. 15, The Terrace. It dates from around 1350, which is when Edward III was on the throne and the Black Death was arriving in England. It is older than Nos 16/18 Rose Street (currently the WADE charity ship), which is a Wealden hall house and dates from the early fifteenth century, although some experts would place it earlier.

The Terrace nowadays sits back from Shute End. The name Shute End derives from an Anglo-Saxon phrase meaning 'the land that stands out'. Shute End is first mentioned in a document in 1321, placing it in the medieval period of the town's history.

This second photograph of The Terrace, which shows a group of no doubt worthy citizens posing in the middle of the road, dates from around 1860. This is believed to be one of the earliest known surviving photographs of the town. It is not too easy to spot, but if you look carefully on the right-hand side, on The Terrace itself, the pub sign of the Queen's Head can just about be made out.

The final image of The Terrace is taken from a postcard and can be dated around 1910. The two ladies in their Edwardian dresses pushing a stroller and a perambulator along a traffic-free Reading Road in high summer make a delightful picture. The path on the right leading up to the houses still exists today, as do the houses, although not clad in ivy. Some, but not all, of the railings also remain in place.

Old Wokingham, the part of the town that we can think of as 'medieval' Wokingham, is the area bordered by Rose Street and All Saints Church, Peach Street, and of course, Market Place and Denmark Street and then stretching out towards Reading alongside The Terrace.

The oldest map we have that shows Wokingham is Norden's map of 1607. But even on the relatively more recent Ordnance Survey map of 1899, the heart of the town can be seen surrounded by open fields. The brick works next to the station are shown, as is the Wellington Brewery in Denmark Street, along the road from the Drill Hall. The whole area of the 'medieval town' covered no more than a couple of football pitches. It was during the second half of the twentieth century that the town expanded rapidly.

Above and below: 1899 Ordnance Survey map of Wokingham.

The Railway Station

The railway came to Wokingham in 1849. It was a momentous event; one that significantly changed the character of the town.

And in a way, it was also a notable commercial coup. Other towns nearby had to wait longer to be connected to the network or were indeed destined never to be part of the railway system at all, like Arborfield or Eversley.

It is important to remember that Wokingham was not really on the way to anywhere, nor was it a major centre of trade. Wokingham has no castle or cathedral. The nearest place of any real note or significance was the royal hunting lodge at Easthampstead, which was built in 1350 by Edward III. Wokingham, unlike Swallowfield of Barkham, did not even merit a separate mention in the Domesday Book.

Much like today, the town was positioned between two major routes, to the north the London to Bath turnpike and to the south-east the London to Portsmouth turnpike. These two routes mirror, to a certain extent, the modern-day M4 and M3 motorways.

As a consequence, the roads into and out of the town were not busy thoroughfares, and this relative isolation was reflected in Wokingham having few inns to accommodate overnight visitors. It was not until the 1750s that a turnpike passed through the town connecting Reading (on the road to the West Country) and Virginia Water (on the London to Portsmouth turnpike) via Wokingham. At that point in history, Wokingham started to be more accessible to and from the outside world. The town was then served by several competing stagecoaches, which took passengers and post to London.

The Swan with Two Necks, 1831, engraved by F. Rosenberg after a painting by James Pollard.

According to this advert from the *Reading Mercury*, 10 October 1774, the fare for an inside passenger was six shillings, and if you were willing to sit up top in the open it was half price:

SWAN WITH TWO NECKS Carter Lane, Doctor's Commons, London. The WOKINGHAM NEW COACH sets out from the above Inn every Tuesday, and Saturday, at Ten o'Clock in the Forenoon. To carry six passengers inside at 6s. each; 14lb. luggage allowed; Children on Lap and Outside passengers 3s. each. Calls for and Parcels at the White Bear and Olde White Horse Cellar, Piccadilly; goes through Hounslow, Staines, dines at the Red Lion, Egham; and from thence, by Sunninghill Wells to the New Rose at Wokingham; from which place it returns every Monday, Wednesday and Friday at Eight o'clock in the Morning.

The elegance of the passengers, the stagecoach, and the general environment, shown in this 1831 engraving, is no doubt an idealised version of reality, which would most likely have been very muddy, smelly and frantic.

In addition to the Wokingham New Coach, which stopped at the New Rose, then located in Peach Street, there were other coaches which started and ended at The Bush Inn in Market Place. In the 1830s, the service was being provided by the Alert Post Coach and Williams Coaches of Reading. But already they were beginning to offer reduced fare for return trips to London in anticipation of the coming of the railways.

The horses and the stagecoaches are long gone, but in the centre of town, just beside the former post office, is a stone mile marker. This gives the distance from the town to Reading as 7 miles and 32 miles to London. Today, the journey to London would typically take one and a half hours and the route, via Virginia Water, the A30 and A4, would not be significantly different from the route the stagecoach passengers would have endured.

Stone mile marker in Broad Street.

The Great Western Railway line from Paddington to Reading and Swindon, and then later on to Bristol and Bath, was opened in the 1840s. The stagecoach companies responded by offering what were in effect connecting services. These services from Wokingham to the Slough terminus were provided by the Surprise stagecoach, which does seem a strange name for a service that you would have hoped would have kept to some predetermined schedule. This left The Bush Inn at 7.15 to meet the Up train for Paddington at 9.40 at Slough and then passengers could return by the Down train, which left Paddington at 4.45 in the afternoon. For the first time, this would have made a day round trip to London tiring but possible.

In 1847, there was a meeting to discuss the proposal for the establishment of Wokingham's station. The great and the good of the town, councillors, church, and businessmen were all present, and there was no hesitation that it would be in the town's interest to 'possess the means of the neatest and most rapid mode of progressing to the metropolis'.

And so it was that the railway was first opened by the Reading, Guildford & Reigate Railway Company offering steam train services in 1849. Subsequently, the line to London Waterloo was developed by the Staines, Wokingham & Woking Junction Railway (SW&WJR) company and started operating in 1856.

Wokingham railway station, 1860.

By 1895, it was possible to travel up to London Waterloo on the 7.20 a.m. train from the London & South West Railway Company and to return the same day by the 9.47 p.m. train. In total forty-four trains were arriving and departing from Wokingham station each weekday.

The photograph shows the station around 1880, and a closer inspection reveals some interesting facts. First, there is only one platform. Secondly, the right-hand side shows a goods wagon, which would have provided facilities for the brick industry that was located nearby. But it is also clear that the unique railway footbridge is missing.

The footbridge is a listed building. It was built from railway sleepers. Its construction was in response to numerous accidents at the level crossing including the following from the *Berkshire Chronicle*, 29 May 1886:

A sad accident took place at the Level Crossing at the Wokingham railway station on Saturday afternoon last. A little girl named Spencer aged 3 ½ whose parents reside at Mount Pleasant while crossing the line in charge of a child not much older than itself had her hand and part of her arm clean cut off by the engine of the fast up luggage train which passes Wokingham after two pm. A young man named Lawrence picked up the poor child and carried her to the station. Dr Hicks and Nurse Swadling was sent for and was soon in attendance, and under the doctor's advice, Nurse Swadling conveyed the little sufferer to the hospital by the next down train. We understand that the child is progressing as favourably as can be expected. The level crossing is the most dangerous place.

The injuries to little Miss Spencer, as well as other accidents and near misses, led to local pressure on the directors of the railway line for the footbridge to be constructed in 1887.

Listed railway footbridge, built in 1886.

Pubs and Inns

There are quite a few drinking establishments in Wokingham nowadays. But following the loosening of licensing laws in the Beer Act of 1830, Wokingham could boast over forty pubs and inns by the end of the nineteenth century. Beer was the national drink, not least because it was a lot healthier than drinking the water, which was likely to have been contaminated. The strength of beer was typically a lot less than it is today, and the alehouse was a place where you could spend time in company with your neighbours, probably with a fire in winter and the chance to eat some hot 'fast' food.

Going back as far as the sixteenth century, Wokingham had sixteen ale houses catering for a population of just under one thousand souls.

The oldest beerhouses and inns that we know date from the early seventeenth century. The Cock, the George, the Hart, the Hinde, and the Bell are all pub or inn signs from this period that are no longer with us.

Within the medieval part of Wokingham, there remain some of our older public houses.

The Queen's Head dates from the late eighteenth century.

The Red Lion, Market Place.

When we visit these pubs and inns, we are in fact stepping back into history, and if the buildings do not retain 100 per cent of their original layout and structure, the ambience, and the atmosphere cannot have changed too much over the intervening centuries. The Queen's Head on The Terrace is located in a sixteenth-century listed building. The pub was first mentioned in the 1750s, but there is no reason to suppose that it did not open its doors to customers a lot earlier.

In addition to the Queen's Head, there is the Red Lion, the Roebuck, the Duke's Head, and the Ship. All these pubs are dateable from the 1750–1800 period. The Red Lion was originally located next to another public house, which was called the King's Head. Both of these pubs were frequently used for council meetings, auctions, inquests and to stage public events, as were the Roebuck and the Duke's Head. The Red Lion and the King's Head were prime locations from which spectators, including the town's alderman, would watch the bull-baiting. The name plaque for W. Churchman is still visible today above the shopfront. This is probably William Churchman, one of a long line of the Churchman family who were licensees at The Rose in Market Place from 1830 to 1907.

The Ship, opposite All Saints Church, was a lodging house, suitably positioned on the edge of town. The Crispin, the Hope & Anchor, the Lord Raglan, Grasshopper Wine & Cocktail Bar (previously the Metropolitan), the Railway Hotel, and the Redan are all Victorian in origin.

The Railway Hotel, as the same suggests, was built to cater for the new arrivals on the railway. Previously, visitors looking for a bed for the night had a choice of the Bush Hotel or the Rose Hotel.

Licensee sign for W. Churchman.

The Rose Inn, Market Place, 1908.

Old documents show that in 1701 a Mrs Sampson was the licensee of the Bush Inn; however, there is some indication that 'the Busshe' existed as early as 1562 and was owned by a Marmaduke Beake of Evendons.

The Rose that we know today is the latest incarnation of three Roses. The first Rose was adjacent to the Bush Inn. This inn most likely started in the seventeenth century, and by 1734 was owned by Molly and Sarah Mogg. Molly is the eponymous 'Fair Maid' of the poem 'Molly Mogg, or the Fair Maid of the Inn'. John Gay authored the poem with contributions from Alexander Pope and Dean Swift, the latter most commonly known as the author of *Gulliver's Travel*. It was first published in 1726. The poem was composed, supposedly, one wet afternoon when the three writers were taking shelter at the inn. It describes the unrequited love of Edward Standen, who was heir to the Arborfield Estate, for the beautiful Molly.

Over the years, there was frequent competition between the Rose and the Bush. They were beerhouses; they were hostelries offering food and accommodation and, in the mid-eighteenth century, the two inns vied with each other for passengers; the Rose and the Bush were the starting/ending point of two stagecoach services.

A lesser-known, at least nowadays, drinking establishment was The Wine Vault at No. 22 Market Place. It was in existence until the 1970s, but its origins are from the eighteenth century, when it was first opened by Paul Holton. Holton was a foundling, an orphan, from London who came to Wokingham as a babe in arms and was adopted. He successfully grew his business, and all the time he was also performing public service and duty as Freeman of the Town, a burgess, a churchwarden at All Saints, a magistrate, and then in 1792, he was elected alderman.

Schools

Montague House is a bit of a misnomer. The Montague family never actually never lived there. The house is eighteenth-century, and Henry Mountague (note the extra 'u'), junior and senior, lived in the seventieth century. Henry senior was born in 1573 and was teaching in Wokingham in 1610. Henry junior was born around 1605 and took over the school in 1634. The speculation is that the Mountague's school was located on the same site as Montague House and that at some time it was destroyed to make way for the newer Georgian building that survives today. The garden at the rear of the house was most likely laid about around the same time as the new house was built and it was then, we can suppose, that the Oriental plane was planted.

We do know that in 1739 the house was the county home of one Colonel Adam Williamson. Williamson spent most of his time in London, at the Tower of London, where he was Deputy Lieutenant from 1722, for almost twenty-five years. As Deputy Lieutenant, he had responsibility, among other things, for the various prisoners incarcerated at the Tower, including Simon Lord Lovat; Lovat was executed and was the last person to be beheaded in England.

Montague House painted by James Smith, c. 1739.

Williamson died in 1747, and later in the same century, the house became the home to Mrs Bloom's school for young ladies. The educational theme continued into the twentieth century, when Montague House became the location for Grosvenor School. The school was run by Miss Laura Baker, who had started life in the town as a governess. She set up her school with her sister at the junction of Broad Street and Milton Road. The house was previously called Terrace Point and is now known as Tudor House. In this photograph, taken just after the First World War, it is possible to make out the sign for the Grosvenor School above the door. When the number of pupils became too large, Miss Baker transferred the school to Montague House.

The Mountague's school lays claim to being one of the earliest teaching establishments that we know. It was probably catering for young gentlemen of the better-off inhabitants of the town. Nevertheless, the education, or at least the nurturing, of the not so well to do of the town was also being provided. Their education was delivered by the many charitable acts of Wokingham's inhabitants. As early as 1520, Thomas Godwin, subsequently Bishop of Bath and Wells, was receiving an education courtesy of All Saints Church.

In 1673, Thomas Martin left money in his will for the education of five male children, for three years, at school. Pragmatically, he also provided for a new cloth coat and a pair of shoes.

Charles Palmer from Arborfield provided £20 in 1711 for the running of a school with twenty poor boys.

Grosvenor House School around 1919 at Tudor House.

For many years, No. 31 Rose Street was the home of the Maiden School. The Maiden School was established in 1795 as a result of a charity provided by Martha Palmer in 1713. The building itself is slightly older and dates from the middle of the seventeenth century. The school was set up for twelve poor girls, eight of the parish and four of the town, who would be taught, up to the age of twelve, to sew, knit and spin cloth. The girls were to receive a bible, a common prayer book, as well as an English Protestant devotional work, and would refer to each other as 'sisters'.

Early in the nineteenth century, the Church of England set up the National Schools, and in Wokingham one was located at No. 21 Rose Street. In 1842, the Maiden School and the Palmer School were amalgamated with the National School. The Maiden School building became the home of the schoolmistress. It was subsequently rented to James Steward, a chimney sweep, in 1875. Steward had been born in the workhouse and rose to be an alderman on the council. However, many people would be more familiar with him in the guise of 'Tom' in Charles Kingsley's book *The Water Babies*. A sculpture, commemorating the book and Wokingham's role in it, is currently located at the entrance to the library. Charles Kingsley was the rector at Eversley from around 1850 to his death in 1875.

The early Victorian period saw an upsurge in the provision of education for all classes. In response to the establishment of the National Schools by the Anglicans, the Methodists set up their schools based on the principles of the British and Foreign School Society. These were designed for children of dissenting parents who were too poor to enable them otherwise to go to school.

No. 31 Rose Street, the Maiden School, 1795–1875.

The British School, in Milton Road, was built by subscription in 1841. The building is listed because it retains the design that was based on the model of the educationalist Joseph Lancaster (1778–1838). Lancaster's idea was that older children would instruct their juniors and be overseen by a master on a raised platform. The actual building was laid out so that it would provide proper ventilation, daylight, and reduce the intrusion of outside noise.

By the start of the twentieth century, the population of Wokingham had grown to over 6,000 in 1901. The 1902 Education Act, sometimes referred to as the Balfour Act, placed increased responsibilities on the local councils. The response in Wokingham was the establishment of Westcott Infants' School, which was opened in 1906 with 222 children aged five to fourteen.

The final school to look at is St Crispin's on the London Road. This is also a listed building. The school was built in 1953, and its prefabricated design was considered revolutionary at the time and provided the template for countless other schools over the subsequent decades. Here the focus was on creating an environment where the needs of the teachers and the pupils were paramount while at the same time enabling cost-effective construction.

From the Montagues in the sixteenth century to the twentieth century, from charity funded schools to schools for young ladies and gentlemen, and church schools, the history of Wokingham provides an insight into the history of education in England.

Wescott Road School children in 1934.

Market Place

Wokingham received a royal charter in 1219 that allowed it to hold a weekly market. The market was to take place on a Tuesday, with the express stipulation that it was to be held 'peaceably'. This market was most likely located in Rose Street and only moved to Market Place when it grew too large. A further royal charter in 1258 permitted the fledgling town to host two fairs, one on the feast of St Barnabas in June and the other on All Saints at the end of October.

All of which paints a picture of the Market Place being regularly full of people, and plenty of hustle and bustle. This was indeed the case when the cattle market and fairs took place. According to an advert in the *Reading Mercury* on 28 March 1785:

> The public are hereby desired to take notice that a Fair will be held in the Market – place, in Wokingham, for the sale of all sorts of ware, cloathing (sic), &c together with all kinds of cattle.

Market day in Market Place around 1900.

At the start of the twentieth century, the following announcement in the local paper could be read on 7 December 1901:

FRIDAY CHRISTMAS CATTLE MARKET Cottrell Simmonds and Butler will hold their annual CHRISTMAS FAT STOCK SALE ...BEASTS, SHEEP, CALVES and PIGS including a consignment of Devon Polled Angus and Welsh cattle, Southdown and Hampshire Down sheep, and prime pork from Col Walter and the Hon W F D Smith...

Cattle made up a significant portion of the wealth of the landed gentry in the seventeenth century, but it was probably pigs and chickens that were much more common. Hogwood and Bearwood resonate with the notion of pigs and pannage, the practice of releasing pigs in a wood so that they can feed on fallen acorns, chestnuts or other nuts. And yet it was the famous fatted chicken of Wokingham that drew buyers from Reading and London to the weekly markets.

The Cattle Trough next to the Town Hall.

The market continued into the middle part of the last century, but after the Second World War, the pattern of trade shifted, and business relocated to Reading and Guildford. Nevertheless, still visible today, as a reminder of these days, is the cattle trough just beside the Town Hall.

The Market Place has not only been a place of commerce. It has been the site of entertainment and celebration.

On 22 June 1911, the coronation of King George V and Queen Mary took place in London, and Wokingham, like the rest of the country, celebrated. The town came out en masse into Market Place. The band is playing, the ladies are showing off their fine hats, the men are wearing their caps or boaters, the soldiers are on horseback and the Boys Brigade is on parade. There is an air of self-confidence about the picture, which shows what appears to be an affluent population.

Little could people in this scene of the royal celebration envisage the carnage that the decade would bring with the horror of Ypres, Flanders, and the trenches. Nevertheless, after several years of war, the Market Place would, once again, be the place where the townspeople would gather, this time to celebrate the end of the First World War.

Hunting and the following of the hounds was an extremely popular 'sport' for the local well to do. The most well-known hunt locally was the Garth Hunt. This would come through Wokingham on their New Years Day outing.

Coronation celebrations in Market Place, 1911.

For many years the hunt was a popular activity not just for the participants. Many people followed the day's activity through reports such as the following 'ripping' report from the *Reading Mercury* 27 March 1897:

Our fox tried the earths in the gorse, finding his entrance barred, ran across over a nice line of country, and there was much grief by the way to Bill Hill. Through the Park he swung at a great pace over the road to Ashridge Wood, but being again headed he bent round to Matthew's Green, where he was viewed not 200 yards in front of the pack. He saved his brush by going to ground in a sewer drain, from which they could not evict him, though he was seen to leave later in the day. This was a ripping good hour's gallop.

It is impossible to leave Market Place without reference to other less salutary pastimes that took place.

Alongside the Red Lion pub is Cockpit Lane. This small alleyway led to the cockpits, which were located where the community gardens are. Cockfighting was a popular pastime and actively encouraged across all strata of society and all ages. The 'sport' peaked in the nineteenth century and then slowly declined in popularity.

Wokingham, however, was also renowned as the last place in England where bull-baiting took place. The event took place on St Thomas' Day (21 December) and was funded through a charitable endowment of George Staverton, a butcher who died in 1661.

The end of the war, 1919.

Garth Hunt meet in January 1960.

The event was no doubt brutal with the bull and the dogs suffering terrible injuries. The crowds must similarly have been whipped up into a frenzy. We can assume drunkenness; we can also assume gambling and no doubt fights. We know of at least two deaths that can be attributed to this barbaric spectacle. In 1794, Elizabeth North was killed when she was too close to the actual baiting, and in 1808, Martha May died as a result of some altercation.

The picture of the baiting shows the chaos. The painting, probably by James Pollard and dating from around 1820, depicts the old Guildhall with its covered walkway or meeting place. On the far side of Market Place, it is possible to make out some of the buildings such as Gotelee House. The artist is painting this scene either just outside or just inside the Red Lion pub.

Bull-baiting in Market Place.

The Town Hall

It is fair to say that the Town Hall dominates the town centre. Love it or hate it, the Victorian mock-Gothic design is anything but discreet.

The current building was opened in 1860 and stands on the site of the old Guildhall. This painting of the Guildhall dates from 1750 and suggests a much more pastoral setting with cows walking about the Market Place. Under the awning on the left-hand side are the town stocks, which are difficult to see without using a magnifying glass on the original. A number of other important features are clear; there is the clock which might connect this building with the one mentioned in a 1583 document about the town council that talked about a 'house in the Market Place called the Clockhouse'. The roof is tiled as the thatched roof had been replaced in 1697. There is the green copper dome, which was a distinct feature of the building. And finally, there are two chimneys on the building. Later, as a result of much-needed refurbishment in 1763, one of them was removed. During the nineteenth century, the building deteriorated and needed significant repair. By the middle of the century, plans were laid for the new Town Hall with which we are familiar today.

Wokingham Guildhall around 1750.

Wokingham Town
Hall, 2020.

The old building was pulled down in 1858, and over the next two years, workmen constructed the new one in apparently a very satisfactory manner. A report in the *Reading Mercury*, 12 November 1859, reads as follows:

> The rapid approach of the completion of our new Town Hall having necessarily brought to a termination the labours of the contracts' workmen. It was felt by many of the inhabitants that a mark of appreciation should be shown of the uniformly orderly conduct of the men during the progress of the works. Accordingly, a subscription was set on foot and being headed by the members of the Corporation in a very short time sufficient was realised to provide a supper and evening's entertainment, and so on Monday last the party assembled and were met by several visitors at the Bush Inn when an excellent repast was served up.

The new Town Hall was proudly opened on 6 June 1860 when, as reported in *London Illustrated News*: 'At an early hour, the bells of the old parish church sent forth their merry peals, and later on, there was dancing which was kept up until four in the morning.'

The Town Hall was a multifunctional building. Its primary role was as the seat of the administration and the mayor's office.

Nevertheless, in keeping with the old Guildhall's provision of a lock-up for vagrants, the new building also housed several cells for prisoners. It was the location of the local magistrates' court with facilities for witnesses.

It served for many years as the headquarters of the local police with accommodation for four constables and their superintendent. The County Police sign remains visible high on the wall today, and the courtyard, a description of its former purpose and function, exists in name only.

And last but by no means least, the building also housed the town's fire engines. Today, it continues to provide both civic, as well as social, facilities but no longer houses 'blue light' services.

County Police Station sign on the Town Hall wall.

Wokingham fire engines, *c.* 1930, housed in the rear of the Town Hall.

Days Out and 'Selfies'

There is somehow the idea that before the coming of the digital age and prior to that television and radio, there were few opportunities for relaxation or socialising, perhaps the exception being the solace of the public house. This next series of photographs shows that the inhabitants of Wokingham in the early part of the twentieth century, had many occasions for a group photograph, perhaps an early equivalent of the nowadays ever present 'selfie'.

The Coronation of George V in 1911 was a significant event. Queen Victoria, who had reigned sixty-four years, had died in 1901, and her son Edward VIII had succeeded her, but had died after less than a decade on the throne. The new king was only forty-five years old when he succeeded to the throne. The empire was still growing and, by 1920, would cover nearly a quarter of the planet. The madness of First World War was several years away. This was a time for celebration. While the grown-ups had celebrated in the Market Place, the town's elementary schoolchildren were given the opportunity to attend an afternoon tea.

As we have seen, fox hunting was a popular activity of the landed classes, but the hunting of hare and rabbit was something that the better-off tradespeople could do. In this picture, a group of hunters pose with their substantial bag of rabbits after a day's shooting at Billingbear Estate.

Children's tea party, Coronation Day, 1911.

A day's shooting.

On the left is George Pither. He was the local butcher whose shop was at No. 15 Broad Street. The sign advertising his business, as an 'English Meat Purveyor', can still be seen today on the side of a building.

The arrival of the new fire engine is clearly an opportunity for a group 'selfie', and perhaps even a competition to see how many people can stand on it at once. This photograph shows the delivery of the new steam fire engine to the Volunteer Fire Brigade in April 1891. The two horses are Tilling Greys and were called Dolly and Dustpan. The photograph was taken outside the Town Hall where the engine was stationed. In this picture you can see the fire station sign, which was removed when the brigade moved out.

Membership of an organisation of any kind can prompt the inclination for a group picture. In Wokingham, as across much of the country in the early part of the twentieth century, the Boy Scout movement was a major outlet for boys and subsequently girls. There was also the Boys Brigade, and in 1920 the Wokingham group are pictured here with their leader staring resolutely into the distance.

The ubiquitous school photograph taken of children in their primary school is a relatively modern convention. Having said that if you attended Palmer School and had a perfect attendance for two years, then it was most appropriate that a photographic record of your diligence be captured. The scene is carefully constructed; the girls have their hair pulled back away from their face, and the boys with their hands placed firmly on their laps as they have been told to do. But the ragged nature of some of the children's clothes cannot be hidden away.

Broad Street in the 1940s with Pither sign visible on the right.

The arrival of the new fire engine pump.

A major event in Wokingham's past is the royal charter that was issued in 1219, authorising it to have a market, while a subsequent charter in 1258 allowed it to host two fairs. The current day May Fayre and Winter Carnivals carry on this tradition of the earlier fairs as this pre-Second World War photograph reveals.

The Second World War called for people to make their contribution in whichever way they could. It also presented opportunities to meet new colleagues and make new friends. The town was very much on the 'home front' and this photograph shows the Wokingham contingent of the Home Guard together with their much-prized radio set.

Boys Brigade, 1st Wokingham Division.

Children celebrating their 100 per cent attendance at The Palmer School in 1896.

Wokingham Carnival, 1932.

Wokingham contingent of the Home Guard.

Churches

There are several churches within Wokingham: All Saints, St Paul's, the Methodist Church, the Baptist Church and Corpus Christi Catholic Church, as well as the Salvation Army in Sturges Road and the Quaker House.

Over the years All Saints Church has been subject to amendments, additions and refinements. The tower is probably the oldest element that remains and dates from the fifteenth century. In the tower there is graffiti that dates from the sixteenth and seventeenth centuries. There is some indication that a chapel of ease existed in 1146. Prior to that there is little reliable information, but it has been suggested that the chapel predates the Norman Conquest of 1066. The church itself was dedicated in 1190 by Hubert, who was the Bishop of Salisbury. Wokingham fell within the diocese of Salisbury until 1836 when it transferred to Oxford.

On Sunday mornings, the church bells regularly ring out across the town. There have been bell ringers at All Saints for centuries. As early as 1350, Wokingham was home to

All Saints Church, W. A. Delamott, 1832.

a bell foundry. The bells from the foundry were at first of inferior quality, but over the years they improved and were to be found in many churches across southern England. The sound we hear today is an echo of the past in many ways; the church bells themselves date from the early 1700s and the sound is reminiscent of the curfew bell for which Richard Palmer, in 1664, provided an endowment for it to be rung at 8 o'clock in the evening, such that, among other things 'strangers who should happen to lose their way in winter might be informed of the time of night and receive some guidance'.

As the town grew during the Victorian period, it became clear that a new church was needed, closer to the railway and closer to the smarter end of town. St Paul's Church was erected on land donated by John Walter III, owner of *The Times* newspaper and Bearwood House; little expense was spared. Walter laid the foundation stone on 2 September 1862.

The Parish Rooms, together with the clock tower, were built in 1863. The church school was subsequently enlarged in 1904 by John Walter's son Arthur Fraser Walter, High Steward of Wokingham from 1895 to 1910.

The Methodists set up their school in Milton Road, but the church, which was originally the Wesleyan chapel, is in Rose Street. A Primitive Methodist chapel was set up at the bottom of Denmark Street in 1856.

A Baptist Meeting House was first established in Wokingham in 1774, although a Baptist church had been established in Reading some years earlier. As the Wokingham church grew, a new building needed to be built to accommodate the increased numbers in the congregation. The new Meeting House was constructed in Milton Road in 1859. It continues to be in use today and forms the current sanctuary and lecture room.

John Walter III.

The Clock Tower.

Baptist Church, Milton Road.

Places of worship are one form of religious expression. But the town has expressed its more profound, spiritual and more caring characteristics in many ways.

All Saints Church commissioned Church House in Easthampstead Road, and its foundation stone was laid in 1901. There was a lengthy article in the *Reading Chronicle* on 12 April 1902, when all the contributors to the costs were thanked. In addition, Canon Sturges set out the aims and objectives of the house:

'What do you want building of this kind for? You have done without it for so many years, and why can't you continue to without it?' The answer was that the world moved on, and every new period of time has brought with it new responsibilities and new opportunities of doing good. Canon Sturges referred to the change which came over public opinion with regard to the education the labouring classes and said it was the pleasure and privilege they had had uplifting a generation of young men and women by means of their schools, which had led them to reflect that their work was not at an end when these children left school.

Church House then set out to fulfil its role as a place for amusement and entertainment, as well as education. But the times change as Canon Sturges mentioned, and in 1915 the role of Church House had to adapt when the First World War started. The house was converted to serve as a hospital for the Berkshire Yeomanry stationed at Bearwood House. There were seventeen beds, and during hostilities, the hospital treated over 500 injured and sick soldiers. The hospital was overseen by Dr Ernest Ward, who was

Church House used as a Red Cross War Hospital, 1915–19.

supported by Volunteer Aid Detachment nurses. The patients ended up coming from many regiments and nationalities as the following medical notes testify: 'Dear Sister Harding, The Australian, William Gibson, came back up here and is in great agony with his foot. Could you possibly take him back for the night?'

And the accompanying notes: 'Gibson - Australian – Queenslander – About 25. Served in Egypt – had a fall from his horse – leg crushed – unconscious for long period. Sailed on the Ballarat – was torpedoed - landed at Plymouth – sent to London. Seen on Wednesday, May 2.' Then on May 14: 'Very good night feels much better.'

In the early part of the twentieth century, treatment of deformities caused by illness, genetic disorders or accidents was not generally available to the broader population. The National Health Service was not created until 1948. Before then the expense of frequent visits to a doctor and the long-term nature of some of these disabilities meant that children would, in many instances, need to bear their discomfiture with little chance of treatment or cure. It was in response to this need that the Memorial Clinic in Denmark Street was established in the disused Primitive Methodist chapel.

The men of the town gave their time and energy without payment to convert the building for use. Many of the fitments were provided free of charge by the Wokingham tradesmen and women. This act of charity was to be a practical memorial, as an orthopaedic clinic for children, to the men who gave these lives during the First World War. The need for the clinic has changed over the years. In 1981, the orthopaedic treatment services were transferred to Wokingham Hospital, and today the building is utilised by the Red Cross.

The Memorial Clinic on the left looking along Denmark Street.

Buildings of Character

It would not be difficult to write a book on the buildings of interest in and around Wokingham. The town possesses nearly 150 listed buildings, and there are many unlisted that are equally worthy of attention. Some of these have already been mentioned. But others have their own unique story to tell.

The elegance of The Elms on Broad Street sits opposite Montague House and alongside two pretty, middle eighteenth-century buildings which in appearance are reminiscent of dolls houses. The larger and grander Elms predates these two small townhouses and is originally sixteenth century, although it was extensively altered in the eighteenth century.

The house's secret claim to fame is its association with a diamond worth a staggering £48 million in today's money. The Elms was the dower house to the Swallowfield Estate, which was owned by Thomas Pitt, who had made his fortune in India. It was while he was there as Governor of Bengal that he acquired the diamond which was latterly called

The Elms, Broad Street.

the Pitt or Regent Diamond. His acquisition has come under a great deal of suspicion. An enslaved miner had originally found the diamond at a mine; he had been killed and robbed by an English sea captain. The sea captain had sold it to a dealer, who had sold it to Pitt, whose son had smuggled it to England in the heel of his shoe! Pitt returned to England and in 1770 bought Swallowfield and The Elms with the proceeds of the sale. The French royal family purchased the diamond, which then graced the hilt of Napoléon's sword at his coronation as Emperor, and today is on display in the Louvre in Paris.

The Old Police Station on the corner of Milton Road was listed in 1987. When the original police station in the Town Hall became too cramped, the decision was taken that a purpose-built facility was needed. The architect Joseph Morris was engaged. His design for the new station included five cells, a magistrates' court, and a charge room. There were also living quarters for four single constables and two married constables, as well as a sergeant.

The Old Police Station, Milton Road.

Heroes and Villains

Claude Duval was of French descent and had moved to England with restored English nobility after the Civil War in the seventeenth century. When he arrived in Wokingham, he decided he needed some form of employment. His career choice was to become a highwayman! Duval was the epitome of elegance and chivalry. He refused to use violence against the people in the stagecoaches that he held up. Famously, he charged a man 50 guineas to watch him dance a 'courante' with his wife, as portrayed in Frith's 1860 painting. Despite his gallantry, a reward was placed on his head, and he was captured and hung at Tyburn in 1670.

Claude Duval is buried in the Church of St Paul, Covent Garden, with the following epitaph:

> Here lies Du Vall: Reder, if male thou art,
> Look to thy purse; if female, to thy heart.
> Much havoc has he made of both; for all
> Men he made to stand, and women he made to fall.
> The second Conqueror of the Norman race,
> Knights to his arm did yield, and ladies to his face.
> Old Tyburn's glory; England's illustrious Thief,
> Du Vall, the ladies' joy; Du Vall, the ladies' grief.

Claude Duval painted in 1864 by William Powell Frith RA.

Miss Spooner arriving for her civic reception on the town's fire engine, 1930.

There is no doubting that Miss Winifred Spooner was anything other than a hero of her age. She lived with her brothers at No. 4 South Place, and rented land along the Barkham Road where she kept her aeroplanes. Winifred was an aviatrix; in fact, she was one of the earliest women pilots.

From Wokingham, she operated her air taxi service taking passengers around England, as well as back and forth to France. But her real passion was the flying competitions and challenges that existed in the 1920s and 1930s. During an ill-fated attempt to fly to South Africa, five days after her departure, her plane crashed into the sea off the coast of Belmonte Calabro, in southern Italy, in complete darkness. The *Western Mail* and *South Wales News* reported on 22 December 1930:

Miss Winifred Spooner, the young English airwoman who crashed into the sea at Belmonte, Italy, on her flight to the Cape, returned to London from Paris unexpectedly on Saturday night. It had been thought that she would fly back to her native place of Wokingham, but for two days Miss Spooner was held by fog, so she came overland. Hundreds of London girls were at Victoria and climbed on porters' trucks and barriers to wave handkerchiefs and give her a cheer. Miss Spooner said that she would like to try the London to the Cape flight again, and she spoke severely about 'some preposterous stories' which have gained currency about her falling 200 feet into the sea and then

having a life-and death swim for hours. 'I never heard anything so ridiculous,' she said. 'How could I fly in an aeroplane at 100 miles an hour, be flung out 200 feet into the sea, and then get up and swim. I should not feel much like swimming, and neither would anyone else. Everyone who knows anything about aeroplanes is roaring with laughter, at some of the tales about me. How would I fall out of my aeroplane! Simply, to get out of the thing is difficult enough, goodness knows. It is true that I did have to swim for two hours.'

Miss Spooner sounds rather formidable!

Charles Goddard joined the police force in 1881 and moved to Wokingham where he was made sergeant in 1895. His career progressed, and he was subsequently appointed Superintendent Goddard. He was a driving force in the creation of the Wokingham constabulary. He was very keen on physical exercise and drill, and partly as a testament to this the photograph shows Wokingham Constabulary as the winners of the 1904 tug of war. Goddard was involved in the case of the disappearance of the famous author Agatha Christie; he was one of the few who correctly believed that she had fled an unhappy marriage rather than committed suicide.

Jesse Gibbons Farbrother was what could be described as a loveable rogue. He must have been an engaging character as he was able to persuade many local people to part with their cash to fund one of his schemes. He was at the heart of it a con man.

Back in 1901, the streets of Wokingham were the scene of much excitement as Jesse Gibbons Farbrother and his fellow investors and enthusiasts put their marvellous Wokingham Whale on display. The strange construction was a flying machine with which Mr Farbrother, according to the *Dundee Courier* on 13 July 1910, would fly from London to Edinburgh!

Wokingham Police Superintendent Goddard, 1904.

In an interview from 2 October 1909 in the *Windsor, Eton and Slough Express*, Jesse gave a full description of his machine with its Captain's Bridge, lavatory and even some type of ejection seat. The Government had, supposedly, expressed an interest and as the reporter noted 'Mr Farbrother is most unassuming and not given to boasting.'

Despite the best-laid plans, things went awry.

The flying machine was lost. Depending on which story you read, it was either in flames or by way of an explosion.

But there are some intriguing points to take on board. Jesse was a carpenter who had zero experience of engineering or flying. Whether the machine was lost or destroyed, he aroused the interest of the police and Jesse was arrested and in 1912 jailed for fraud. After he left Wokingham his career went on to include the fraudulent selling but not delivering of typewriters for which he received another prison sentence. However, there was much intrigue at the time of this investigation. It was reported initially that he had committed suicide in Bath, and indeed the body was positively identified by his landlord. Subsequently, however, he was arrested, in 1919, in Scarborough, in possession of stolen goods. He was calling himself James Fairbrother at the time. The papers were full of reports of 'The 'Mystery Man' and the 'Remarkable Case of Mistaken Identity', as per the *Leeds Mercury*, 19 June 1920:

The Wokingham Whale at Farbrother's Yard in Wokingham.

The charge of having stolen watches, typewriters and other articles, preferred against a man calling himself James Fairbrother ... it was stated that he was similar in appearance with a man of the same name who was found drowned in a bath in Bath last week ... there was certain suspicions attached to the man with regard to his identify, because he was found that he was known as Jesse Lowell in Bath in 1902 and was known as Jess Fairbrother in 1911 at Aldershot.

The mystery was slowly unravelled, and Jesse served his jail time. He ended up living in Poplar, London, and died in 1937. The fate of the Wokingham Whale remains unknown.

It is difficult to walk around Wokingham or Barkham or Finchampstead without the name Walter coming up. John Walter III was a significant benefactor of the neighbourhood. His son Arthur Fraser Walter is often overlooked. Arthur was the Chief Proprietor and Chairman of *The Times* newspaper. He was also the High Steward of Wokingham. Among other things he was responsible for the erection of the clock tower that is prominent on the corner of Station Road and Reading Road. Living in the shadow of his father might have been a challenge, and hence he is nominated here as a local albeit often unsung hero.

Arthur Fraser Walter.

ICYMI: In Case You Missed It

There are many aspects of Wokingham's past that can be easily missed and overlooked if their relevance is not appreciated or understood. Consider No. 21 Market Place, which is currently occupied by the Edinburgh Wool Shop. The shopfront and the interior of the building date from the 1970s. The frontage was rebuilt at the same time, although it mirrors the old building. The only element of the original building completely unscathed is the elegant doorway.

Wokingham lacked a Catholic church for many years, with people attending St James' Church in Reading. In 1903, a Miss Johnson of Ascot invited the Dominican Sisters of the Convent of the French Sisters of the Presentation of the Blessed Virgin to open a convent and school in Wokingham. This was at No. 21 Market Place, which was described as 'une jolie et grande maison', a pretty and large house. The sisters moved out in 1907 to Easthampstead Road.

The Wokingham Club in Denmark Street.

In the latter part of the Victorian era cycling was an exceedingly popular sport and the Wokingham Cycling Club had been formed in 1889. The club's headquarters were in Peach Street, but the inability to serve alcohol on the premises prompted them to look elsewhere. The Cyclists Club amalgamated with the then practically defunct Wokingham Working Men's Clubs and in 1892 the decision was taken to adopt a new name. Henceforth it became known as the Wokingham Club with new premises in No. 3 Denmark Street. Nevertheless, after a few years, the club outgrew its home in Denmark Street and in 1910 Howard Palmer, a director of Huntley & Palmers, a keen cyclist and local benefactor, purchased No. 21 Market Place and donated it to the Wokingham Club. Subsequently, in 1930, Howard's son, Reginald, acquired land for club members to use as a bowling green, nowadays the Howard Palmer Gardens. Wokingham Club prospered until the 1950s when changes in leisure interests and the advent of television impacted membership. It was finally closed in 1960.

Over 18,000 pillboxes were constructed in Second World War across the British Isles to resist the Nazi invader during Hitler's proposed *Operation Sealion*, which was the planned German invasion of England set for 1940. Many of these were set up on defence lines around existing military establishments like Aldershot or Arborfield. The nearest defence line to Wokingham followed a route down from Three Mile Cross to Aldershot, then along the south of Guildford to Maidstone and Rochester. Wokingham was not a strategic town or position and so did not warrant a substantial number of pillboxes. There are several in the area but the only one identified in Wokingham is on the London Road by All Saints Church. This was most probably erected by the local Home Guard.

Peach Street during the installation of much-needed sanitation.

In some ways, a sewer ventilation shaft can be thought of as something a little unsavoury. But it was an essential element of the Victorian sewerage system that was built on what is now the industrial estate behind Ormonde Road Allotments. The shafts, and there are several around Wokingham, look a little bit like lampposts without the lamp or a Mississippi river boat funnel. They were needed to allow the methane gas to vent and avoid a build-up and consequential risk of explosion.

Wokingham had a notorious legacy in terms of health, safe drinking water and waste disposal. Despite numerous calls for action and legislation, as relatively late as 1870 an inspector wrote that Wokingham had 'the worst waters I have ever met with. It has more than twice the manure value than average London sewage'. The construction of the new sewage system was long overdue and significantly improved the quality of life for the inhabitants of the town.

Even though many old houses remain in town, others have succumbed to the passage of time and the developer. These cottages towards the All Saints Church end of Rose Street show signs of disrepair and were demolished in the 1950s.

Gotelee House stands today in Market Place as it has done since the middle of the eighteenth century, when William Gotelee first commenced his printing and publishing company. Gotelee published compendiums, a collection of articles about specific themes and subjects, as well as books. The shop continued through to 1936 when it became WHSmith. Gotelee was much involved in the town and published petitions such as one from 1846 entitled 'The Petition presented by the Churchwardens of Wokingham to Both Houses of Parliament containing The Correspondence of The Dean of Salisbury, his

Tudor Cottages, Rose Street.

lessee and agent with the Churchwardens and The opinion of Dr Addams as to the Law of the Case'.

Wokingham nowadays is one of the more well-to-do towns in the affluent south-east. It ranks high on the list of 'best places' to live. But it was not always the case. In the nineteenth century, there was the risk of disease from poor sanitation, the cattle market was run down, and there was little or no industry. All Saints Church was in a state of disrepair and the churchwardens were struggling to receive funding from the diocese as an extract from the petition reveals:

> There is every appearance of extensive dilapidation along the whole of the north side of the Church, especially that part of the aisle adjoining the chancel; the north wall is very much out of perpendicular and is now scarcely supported by the buttresses which have been added, as is evident from the almost ruinous state of some of the Windows and the lower part of the Roof.

The church community was asking for much needed money and not for the first or last time would local people need to dig into their pockets to provide much needed support to their church and town.

Gotelee House, Market Place.

The improvised state of some parts and some of the citizens of the town is also reflected in the ongoing need to house and look after the town's paupers in the workhouse.

The old workhouse in Denmark Street was first established in about 1776 and housed typically twenty-five inmates but had beds to accommodate up to fifty. The inmates were given work to complete, which, if they refused, their only other option was hard labour or imprisonment. There was only one fire in the building, and few other amenities so at times the inhabitants must have felt the chill of their surroundings. It is important to recall that the Workhouse was designed to be a place of last resort, but it was often the only refuge for the old, sick or infirm. New legislation in 1835 established Workhouse Unions, which led to the Old Workhouse closing in 1835. The inmates were moved to a new facility in Wargrave, but this was deficient in many ways and led to the call for a new building to be built in Wokingham to house the town's destitute. This was the new workhouse or as it has subsequently become Wokingham community hospital in Barkham Road. The following announcement was made in the *Reading Mercury* on Saturday 29 July 1848:

WOKINGHAM The guardians of the Wokingham Union propose to build a new workhouse for the accommodation their poor, instead of sending them to the Wargrave house; and we are informed that Mr John Billing was appointed the architect at the meeting on Friday last, his designs having been preferred by the guardians and the Poor-law commissioners, to many others which were then presented to their notice.

Denmark Street, 1930s.

Streets

The streets of Wokingham help to tell the story of the town.

Wiltshire Road runs from Peach Street through to Bell Foundry Lane. By way of passing, Bell Foundry Lane is not where the bell foundry was sited. The bell foundry was probably situated somewhere behind Nos 7–15 Broad Street named Smyths Place. Bell Foundry Lane was where William Landen had a farm. Landen was the owner of the Wokingham foundry in the fifteenth century.

Nowadays, Wiltshire Road is frequently busy with traffic. But there are some wonderful photographs showing a much earlier and quieter road. This photograph from the early twentieth century, shows young children playing by the side of the road while the milk float of F. A. Palmer passes by, with several bicycles against the wall and on the pavement. The photographer is standing just beside the graveyard of All Saints Church and in front of the fifteenth-century Richmond Cottage, not in the picture. The house on the left exists today.

The question to be asked is why it is called Wiltshire Road. The simple answer is that the part of the town on the right-hand side of the road was, for many years, in Wiltshire and not far along the road was Wiltshire Farm.

Wiltshire Road, *c.* 1910.

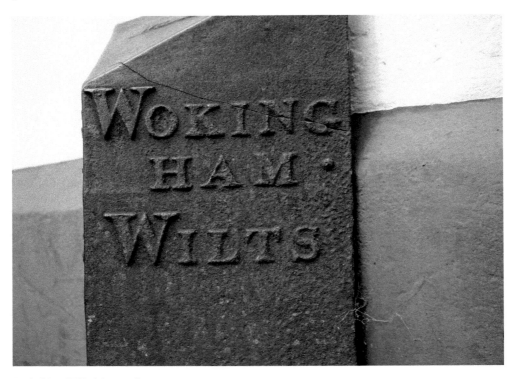

Berkshire–Wiltshire marker stone.

Wokingham was part of an Anglo-Saxon province that included most of east Berkshire. In AD 960 King Edgar gave the western part of the county to the Bishop of Salisbury. This was called the Hundred or Manor of Sonning. Sonning was the location of the minster church. The remaining area was retained by the king and for administrative purposes was included in his Manor of Amesbury. Amesbury is in Wiltshire and so administratively the area to the east of Cross Street, the actual boundary line, was in Wiltshire. The situation did not change until as relatively late as 1885.

The marker stone is still visible today, but it has been moved from its original location in Cross Street to the corner of Wiltshire Road and Rose Street.

Peach Street has always been a thoroughfare, and indeed some large buildings associated with the industry of the town such as the sawmills and a silk factory were located along its length. More recently Peach Street has been the home to shops and stores.

This second photograph, in point of fact, a postcard posted from 1960, of Peach Street with the car, the Coca-Cola sign, the street lighting, the Galleon Tea Rooms, and the awnings compares with the first one from before the war, which is taken in roughly the same position. The earlier photograph has horse droppings in the road, a gas lamp, and shop wares on the pavement.

Times might change, but some things remain while others fade; the Redan pub is in both photographs and remains open today, serving beers since 1845. The Welcome Inn selling Henley beers closed down.

Peach Street in 1926.

Peach Street looking west in 1960.

Broad Street, 1905.

There is no shying away from it, but Broad Street, which was formerly called the High Street, was the posher end of town. The Elms, Montague House, Tudor House, and Markham House are all grand houses set on a broad street with a view towards the Town Hall. The road is aptly named, with its breadth no doubt accommodating the elegant carriages of the more affluent citizens of the town.

Towards the Town Hall, Broad Street becomes slightly less refined, and there are butchers and dining houses, and then Rose Street, with its alleyways and courts, empties and spills out. Rose Street was a more upmarket retreat at several times during its existence. Lucia Webb lived at Nos 45 or 47 Rose Street. She was the sister of Sir William Webbe, Lord Mayor of London, and the mother of the future Archbishop William Laud, who was born in Wokingham in 1597. In his will Archbishop Laud left the sum of £50 per annum to be divided between three poor girls towards their marriages and then for five poor boys towards their apprenticeships.

This delightful painting by Miss C. M. Forster dates from 1893 and offers a colour image of Broad Street. Caroline M. Forster lived at Shute End. She was a teacher or rather drawing instructor as she described herself in the 1901 census. She resided in Wokingham with her mother and two sisters, Francis and Elizabeth, both of whom were also teachers. Caroline was likely related to Michael Seymour Forster, who was the bursar of Wellington College.

Broad Street, 1900.

Broad Street, painted in 1893.

Market Place, 1902.

Market Place has been the location for many different shops and outlets over the years. Clark & Sons in the left corner of the photograph were grocers who took over No. 18 Market Place from Alexander Grover in 1901. Clark & Son moved in 1903 and were replaced by the International Tea Company.

The Wheatsheaf pub, which is visible in the left-hand corner, served Wokingham's drinkers from the late Victorian period through to 1986. The Roebuck is a few doors up and at the top of the street is Bigg and Gould fishmongers with their white awning.

This later photograph shows a more modern and familiar Market Place. The town seems relatively empty even though there are lots of cars parked in front of the Town Hall, and along the road. The traffic is flowing in both directions and on both sides of the Town Hall. Slightly difficult to see is the No. 3 bus from Reading that is just coming into view on the left-hand facing side of the Town Hall. The focal point for the photograph is the conversation taking place in the foreground between the policeman, who appears to have his notebook out, and the older cyclist. 'So, you think that this will one day be pedestrianised and a one-way traffic. With coffee shops and restaurants selling foreign food stuffs! Have you been drinking, sir?'

Denmark Street was previously known as Don or Down Street as logically it walks downhill to the Emm Brook. The name was changed in 1863 to commemorate the marriage of Princess Alexandra of Denmark to the future King Edward VII. The pub on the left in the photograph, at No. 20 Denmark Street, is the Royal Exchange. W. C. Parfitt was one the last licensees; the pub closed its doors in 1958.

Market Place around 1910 with The Wheatsheaf pub on the left.

Market Place, 1950s.

Above: Denmark Street with The Royal Exchange pub on the left.

Left: Denmark Street showing the layout of the old burgage plots.

Some of the older properties in Wokingham reflect the historical and indeed the original layout of the town. Denmark Street was an area of narrow strips of burgage plots. These were plots of land that the lord of the manor, or the medieval borough, rented to townspeople. As they were typically close to the marketplace, they were narrow and long, with a shop or dwelling place at the front and a field, orchard or workshop out the back. Along Denmark Street, many of these burgage plots have been combined into two or even three and four houses. However, if you look carefully along the street the original narrow strips can still be made out, for example, No. 17 Market Place currently occupied by Blue Cross charity; the building itself dates from around 1575.

This photograph of Denmark Street shows the Primitive Methodist Hall before it was converted to the Memorial Clinic. There are gas lamps on both sides of the street, and on one side there is a sewage pipe vent, there are horse droppings in the road, and the Crispin is selling Simonds beer.

Denmark Street.

No Longer with Us

Many buildings are no longer with us either because they did not survive the ravages of time, or the developers' pen swept them away. Nevertheless, we are in possession of photographs that give us a glimpse into this lost world.

Alderman Billy Martin was a great believer in the benefits of swimming and tried over many years to persuade the council to invest in a pool for the town but without success. And so, in 1934 he had designed and built a swimming pool in the grounds of his own garden that he would open to the general public. Martin's Pool was the epitome of art nouveau elegance with walkways, fountains and landscaping. Pageants and diving events would be held at the pool. Film stars and celebrities would be persuaded to visit. It was a roaring success, so much so that the council eventually took over the venue. However, over time it grew less popular against the competition of the attraction of indoor heated pools. Martin's Pool's sad, and much-lamented, demise was in the 1980s when the Carnival Pool replaced it. The Carnival Pool, itself demolished in 2020 to make way for a new one, was named after the fact that its location is where the annual carnival or fair took place, in some of the former grounds of Elms House.

Many pubs are no longer with us. This photograph shows the White Hart, which was located at No. 65 Rose Street and probably closed in the early part of the twentieth century. The image does appear rather desolate, but the upstairs windows are wide open suggesting a summer's day. A man is standing in the doorway, pipe in hand with his young son holding his hand.

Martin's Pool.

Above left: The White Hart, Rose Street.

Above right: Tudor cottages, Rose Street, 1890.

This photograph of Tudor Cottages shows Rose Street without a pavement, and probably dates from the 1890s. The five children are looking rather nervously at the camera. This image of Rose Street gives a clear indication that poverty was very much present in the town despite its Victorian refinements.

The second photograph, taken a few decades later, suggests that the buildings had received some attention, but they remain looking destitute. They were eventually demolished in the 1950s.

Wokingham started out as a small collection of houses, or most likely huts, around a chapel of ease providing support and succour to the first inhabitants. Over the years, many residents of the town have demonstrated their charity in multiple ways. In 1451, John Westende left an endowment in his will for eight almshouses. These were located opposite The Ship on Peach Street. These were joined in the nineteenth century by the Victorian almshouses. Regrettably, both were demolished in 1978, and in their place there is now Westende House and Queen Victoria House flats.

Today, Wokingham now has its own cinema, but it had lacked one since the 1980s when the Ritz in Easthampstead Road closed. The first cinema in town was the Electric Theatre, also known as the Savoy. This was in Broad Street and had opened to paying customers in 1913.

Tudor cottages, Rose Street, 1906.

Westende and Queen Victoria Almshouses.

However, the Savoy was not the first 'theatre' in town. According to the *Reading Mercury* of 1 November 1784:

At the THEATRE in WOKINGHAM, ON Monday evening the 1 November 1784, will be presented a Comedy, call'd, The BEAUX STRATAGEM; With the Humours the Litchfield Landlord. To which will be added, A Farce call'd, The HONEST YORKSHIRE MAN; On Wednesday evening, (by particular desire). The Provoked Husband. or, a Journey

Electric Theatre in Broad Street.

to London. With the KING AND MILLAR OF MANSFIELD. And on Friday evening, a Tragedy called, ROMEO AND JULIET and a Farce called CROSS PURPOSES. With variety of Interlude each evening between the acts. Pit 2s. Gallery 1s. The doors to open at half past five.

A 'Guided' Tour of Secret Wokingham

For anyone wishing to take a brief walk around town to explore its history, there is no better place to start then the Wokingham Society's Blue Plaque Trail. The trail follows the blue plaques that the society has placed around the town identifying buildings and structures of historical and cultural importance.

This concluding section will build on the Blue Plaque Trail, identified with an asterisk in the following text, and take us on a walk around the town and through a thousand years of history. The walk is about 3½ miles long and typically would take one and a half to two hours at a leisurely pace.

1. Montague House Garden: The starting point is where the book started and the Oriental plane tree in the garden of Montague House. The garden and tree are visible from the supermarket car park. There is also a plaque on the railings.

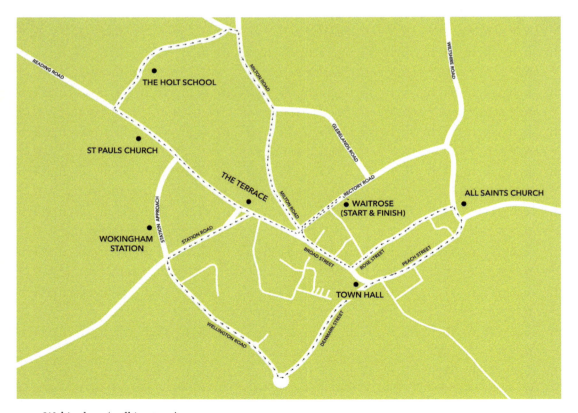

Wokingham 'walking tour'.

2. As you come out of the car park turn left to start walking along Rectory Road. The road was previously a footpath until No. 43 Broad Street was demolished to make way for the road in 1870. It was laid out on the glebe lands of All Saints Church and named after the rector's house which was built for Canon Edward Sturges. Sturges was rector from 1873 to 1904. Behind us is Glebelands Road, which cuts through the land that originally belonged to the church. The Palmer School was also located nearby as a result of the 1711 charity of Charles Palmer.

3. Rectory Road orchard and nurseries: Formerly the area occupied by the Old Police Station had been a garden nursery. All of the land on this side of Rectory Road made up the rectory gardens until the 1940s. The name Orchard Place leading off from the road gives a pointer to its usage and heritage. The orchards and garden nursery most likely predate the Victorian era and the building of the rectory itself and are left over from various earlier medieval market gardens. Anecdotally, Canon Sturges would allow the local children to go scrumping for his apples.

4. Old Police Station: There are some Victorian buildings on the left as you come to the end of Rectory Road and on the right is the Old Police Station. The police moved out of the Town Hall and relocated to this purpose-built facility in 1904.

5. Tudor House*: As we turn into Broad Street Tudor House is on the right. It is a sixteenth-century house proudly standing at the head of Broad Street flanked on one side of the street by the equally elegant Elms and on the other by Montague House. Some of its internal beams, panelling and fireplaces are understood to have been sourced from

Servants of Canon Sturges.

A view towards Market Place from Broad Street, 1900s.

Billingbear House, which was destroyed by fire in 1924. Research suggests that most of the external beams are original and were exposed in the 1920s when Miss Baker's school moved out to Montague House.

6. Shute End: As you walk along Shute End, it is worth pausing to admire the collection of listed buildings. In this short space of 200 metres, and what is nowadays a busy part of Wokingham, there are buildings dating from the sixteenth century through to the nineteenth. Shute End is an old part of the town and the name comes from the Anglo-Saxon 'shete', which roughly means 'the land that sticks out' or shelf. It is first mentioned around 1300. Corpus Christi Catholic Church was located in the Shute for a few years until 1911.

7. No. 15 The Terrace*: This is one of the oldest houses in town and dates from the mid-fourteenth century.

8. The Queen's Head*: Continuing along The Terrace a little bit further up is the Queen's Head. This is a fifteenth-century hall house. A hall house was essentially a large room surrounded by four walls with a roof. There might have been adjacent rooms, but the hall itself was where people ate, slept, and kept warm. There would have been a hearth in the middle of the hall with smoke rising upwards through an opening in the roof. Little of the original interior of the hall house survives, but, nevertheless, it offers a good excuse for popping in to sample the wares. The earliest record of the Queen's Head as an alehouse and dates from 1777. Prior to that date it was probably a private dwelling.

THE TERRACE, WOKINGHAM.

The Terrace.

To put that in context it is a year after the American War of Independence and a decade or so after Captain Cook landed in Botany Bay. The Queen's Head was accompanied for many years by the Anchor, which opened in the 1770s and closed around 1910; it was located a few houses along at No. 37 The Terrace.

9. St Paul's School and Clock Tower: On the corner of Reading Road and Station Road is the Clock Tower and St Paul's School. The school was opened in 1866 and had been built with donations from John Walter III, owner of *The Times* and Bearwood estate. His son Arthur, who became Steward of Wokingham, added additional classrooms and extended the playground. In 1911 Thomas Ellison of The Elms bought the building off the Bearwood estate for the benefit of the town. The Ellison family were great benefactors to the town.

10. Windsor Forest Turnpike: Reading Road leads, naturally enough, to Reading. But rather than think of it as it is today, tarmacked and laden with cars, it can also be imagined as part of the Windsor Forest Turnpike, deeply rutted with stagecoaches carrying their passengers across the open countryside. Windsor Forest Turnpike connected Reading via Wokingham and Ascot to the London to Portsmouth Turnpike at Virginia Water.

11. Masonic Lodge: A bit further along on the right is the Masonic Lodge. This building was previously the brew or malt house of Beeches Manor. Its original layout had two storeys. The second storey windows can be seen outside. The building probably also had a higher rood and was thatched. The ceilings would have been lower and most likely the floor probably about 2 feet lower and quarry tiled.

The Masonic Lodge, previously the Malt House of Beeches Manor.

St Paul's Church.

12. St Paul's Church: The early part of Victoria's reign saw a more refined and prosperous enclave in Wokingham established around Broad Street. At the same time, All Saints Church had fallen into a state of disrepair from which it would need ongoing attention. The area around Rose Street had similarly fallen into one of its more impoverished periods. Across Wokingham, the population was increasing, the 1861 census records over four thousand inhabitants. The railway had also arrived in 1849 to add to the busyness of the town. All of these factors led to the call for a new church in Wokingham. The church was consecrated on 23 July 1864. However, all was not entirely fit for purpose, and some additional refinements were required to improve the acoustics and to accommodate the growing congregation. Its spire rises to 170 feet above the town. The bell tower was destroyed by fire in 2004 after a lightning strike. This led to a need to recast the bells at the Whitechapel foundry.

13. The Holt: Holt Lane presents a slight climb over a rise which skirts the higher ground on which Wokingham is located. On the left is Joel Park, which backs onto Holt Copse. This remains a place for walks and picnics. It was originally part of the grounds of Beeches Manor. Today on the right is the Holt Girls' School. The administration block for the school is the former dower house to Beeches Manor; it is just behind the old brick wall. Above the entrance are two dates: 1648 and 1886. The relevance of the dates is questionable. The first date is close to the period when ownership transferred from the de la Beche family to the Whitlockes. The 1886 date probably correlates to when significant alterations and repairs were made to the building.

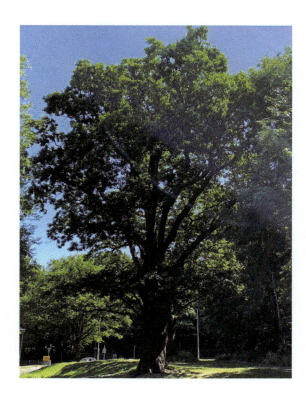

500-year-old English oak veteran tree.

14. Veteran Trees: Within Joel Park, as elsewhere around the town, there are some magnificent veteran trees, many of which are probably 250 years old. Before we turn into Milton Road, there is an English oak which, judging by its girth, could be anything up to 500 years old. As such it was a sapling when the Spanish Armada threatened England only to be defeated by the weather and, of course, Sir Walter Raleigh.

15. Glebelands: Glebelands in Milton Road was built in 1890 by Alfred James Nicolson. He was the son of Edward Nicholson, who had made his fortune in linoleum. The building is now a care home. Earlier it was owned by the Cinematograph Trade Benevolent Fund and provided residential care for former workers in the film and entertainments industry.

16. Milton Road: Milton Road is named after the poet who was much admired and studied in the Victorian era. The road was formerly known as Nonsuch Lane.

17. The British School*: Milton Road takes us towards the Baptist Church. On the right before the church itself are the Martin and Pole Auction Rooms. Formerly this was the British School established by the Baptist Church in 1841 for 'dissenting parents' who could not afford to send their children to school.

18. Baptist Church: Further down the road is the Baptist Church itself. This is a listed building and is described by Historic England as being built 'in an eclectic Victorian style'. There have been Baptists in Wokingham since 1762. A Baptist Meeting House was built in Milton Road in 1774, and a separate Wokingham Baptist Church was established. As their congregation grew during the early part of the nineteenth century, they saw the need for a larger building. The new building was completed in 1861 and is now used as the sanctuary and lecture room.

Milton Road in 1910.

Hope & Anchor pub.

19. Hope & Anchor pub: Turning the corner we walk along Shute End again before turning towards the station. On the right is the Hope & Anchor pub. The building was originally a fifteenth-century hall house. The pub started serving customers in the 1830s and enhanced its business by offering rooms as well as a smithy (to the left of the pub entrance). There was subsequently a garage for motor cars in the 1920s. Towards the end of the nineteenth century, the pub belonged to the Wokingham Brewery, whose brewery was located in Broad Street.

20. Station Hotel or Tap: The Railway Hotel or Tap was opened in 1849 to coincide with the arrival of the railway. The Three Brewers, which was across the railway line, closed a few years ago. It was another Victorian pub that came about as a result of the increased custom brought by the railway. If we continued a short distance along Barkham Road past the Three Brewers then we would find the former Union Workhouse, opened in 1848, now serving the community as the Wokingham Hospital.

21. Railway Station: The current railway station opened in 2013, replacing the one which was built in 1972. The first station was opened in 1849. The transportation of goods rather than passengers was the primary source of profit for the early railway. Around Wokingham station there would have been a hive of activity with brickworks and a goods yard.

22. Railway Footbridge*: The footbridge over the railway is made from sleepers. It was constructed in 1886, after several serious accidents at the crossing and a letter to *The Times*.

Railway Hotel.

Railway station, opened in 2013.

23. Cricket Ground: Keeping this side of the tracks and walking along Wellington Road, the right-hand side is a relatively new housing estate and on the left some older properties. The Wokingham Cricket Ground has now moved out of town, but its ghost remains in the names of the roads on this new estate. The club had played its first match in 1767 against Henley and was officially founded in 1825. The land was a gift of Mr Goodchild, who provided what was known as Goodchild's Meadow and latterly became Wellington Cricket Ground. The club moved out in 2012.

24. Elms Field: Wellington Road is at the rear of The Elms, and most of the land that is on the left formed what was once the gardens to the house. Today it forms the basis for Elms Field. The Carnival Pool at the corner of Wellington Road similarly sat on land that was originally part of the estate. Indeed, during the early part of the last century the two sisters of Thomas Ellison who inherited The Elms after their brother's death allowed the annual town fair or carnival to be held on their land, hence the name.

25. The Emm Brook: Before turning up Denmark Street, it is worthwhile taking a glance down the hill. This leads to where the Emm Brook crosses the road and provides evidence to the observation that Wokingham was established on a slight rise. Also, just down the road from here was the old Wokingham Football Club and ground, which sadly closed in the 1990s.

Sculpture commissioned by the Wokingham Society.

Duke's Head pub.

26. Duke's Head pub: On the corner of Denmark Street and Langborough Road is the Duke's Head public house. The Duke's Head is one of several public houses that we will 'visit' on this walk. This pub can be dated from 1795 and was formerly three cottages. Out the back, in what was the yard, is a skittles alley, which is housed in a building dating to the seventeenth century.

27. Memorial Clinic: As we go up the slight hill along Denmark Street on the left is the Memorial Clinic. This was formerly a Primitive Methodist chapel. It was set up as a clinic after the First World War, as a memorial to the fallen, to provide orthopaedic services to the town.

28. The Water Babies sculpture: The library was previously located on the corner of Denmark Street and Langborough Road. At its entrance is a sculpture showing two of the characters, chimney sweep Tom and the upper-class Ellie, from Charles Kingsley's children's novel *The Water Babies*.

29. Nos 51 and 53 Denmark Street: A relatively well-to-do house from the late sixteenth century.

30. Nos 47 and 49 Denmark Street: Early nineteenth-century house. Notice the three doorsteps to lift the house out of the mud and other detritus which would frequently cover the road.

31. Nos 37 and 39 Denmark Street: Two early seventeenth-century cottages.

The Crispin pub, Denmark Street.

32. The Lord Raglan: The pub dates from the 1830s and no doubt came about because the Beer Act of 1830 made it easier to brew and sell beer.

33. Nos 31 and 33 Denmark Street: Early seventeenth-century cottage with a great example of exposed timber and infill.

34. No. 35 Denmark Street: Another hall house from the late fifteenth century.

35. The Crispin public house: The Crispin is one of the oldest buildings in Wokingham. It dates from the fifteenth century and was built as a hall house. The pub itself can be dated from the Victorian period and attributed to the Beer Act.

36. The Wellington Arms, No. 23 Denmark Street: The Wellington Arms closed in 1921. It started life as The Chair, a pub owned by the Hayward brewery. Local plumber Robert Trickey Dunning bought the brewery in 1856. He renamed it the Duke of Wellington, the Wellington Stores and finally the Wellington Arms. Dunning then purchased the land behind the pub and opened the Wellington Brewery, which was eventually sold to the Headington family and then Ashbys of Staines. It closed down in 1927.

37. The Drill Hall: The Drill Hall does not exist today, but it stood behind the current façade near Erfstad Court. The hall was used by the local territorials as well as regular or enlisted soldiers during the two world wars. The date stone of 1881 marks the entrance to the hall.

38. Nos 22–25 Denmark Street: A row of early sixteenth-century cottages with a stone or timber yard to their rear. No. 22 also housed the town's original workhouse. The old workhouse was replaced by the Union Workhouse in Barkham Road.

39. The Royal Exchange public house (No. 20): A lost pub, one among many that closed sometime in the last century.

The Drill Hall.

Market Place.

Market Place, 1960s.

40. Listed buildings: Continuing along the street, we pass from one listed building to another. Sometimes it is good to look up at the houses and buildings away from the twenty-first-century shopfronts. The first storeys, roofs, and chimneys are frequently little changed over time. Similarly, if it is possible to view the back of houses from say the car park. This can be revealing in identifying features, small and large, that have not been changed by the fashions or dictates of time, and which would otherwise go unnoticed.

41. No. 10 Denmark Street: Mid-sixteenth-century small hall house.

42. Nos 8 and 8a Denmark Street: Early seventeenth-century house.

43. Nos 4 and 6 Denmark Street: Early nineteenth century.

44. No. 2 Denmark Street: Early seventeenth century.

45. Market Place: It would be easy to write multiple books on all that has gone on in Market Place. For example, there was the All England championship boxing match between Tom Johnson and Bill Warr in 1787. Infamously, there was bull-baiting as late as 1855, and cockfighting, behind the Red Lion pub, at the end of Cockpit Lane, beyond the town's boundary. It was in Market Place that the population cheered the end of the Boer War and the First World War, as well as witnessing the troops heading off to Normandy and the D-Day landing. The Market Place has seen the announcement of election results, as well as the celebration for the coronation of kings and queens.

46. The Wokingham Club, No. 19 Market Place: The building was provided as a home to the Wokingham Club in 1910 by W. Howard Palmer. The club was an amalgamation of the Wokingham Cyclists and Workingmen's Clubs. The building itself was gutted by fire,

Gotelee House, around 1910.

but the original door remains on the left-hand side of the present shop. The Wokingham Club offered a meeting place as well as facilities such as billiards and a bar.

47. The Red Lion: The Red Lion pub with its side alley allowing access to the cockpits behind and the stabling. The pub itself dates from 1782 and played host to town meetings and auctions.

48. The Roebuck: On the opposite side of the Market Place is the Roebuck. This is also another old pub dating from 1750; it is located in a sixteenth-century house.

49. Gotelee House: Alongside the Roebuck is Gotelee House, which is a fine Georgian building. Gotelee House was the home, for many years, to the Gotelee printing and publishing company.

50. The Rose: This is the most recent name of the Olde Rose Hotel, which itself was the third establishment of that name in town. The first was adjacent to the Bush Hotel at Bush Walk; this was the home of Molly Mogg, the barmaid of the poem of the same name. The Rose's second home was further along Peach Street. This incarnation came about in 1772 when the rent for the first location was significantly increased; it lasted until 1790. The Olde Rose, the one known today in Market Place, was established in 1844.

51. Town Hall*: And then we come to the Town Hall itself. Opened in 1860, the new building replaced the older town hall. It is interesting to walk around the town hall. The entrance to the courtyard is the entrance to the former magistrates' courts and lock-ups. Around the back are the arches where the town's fire engines were housed. As you pass along the north side of the building, do not forget to notice the drinking fountain and

Town Hall, 1897, Queen Victoria Jubilee.

Bush Hotel, Market Place.

telephone box, both of which are listed buildings. The drinking fountain dates from 1881, whereas the K6 Telephone Box is one of the earlier types used outside of London. And then as you come around to the eastern wall look up to see the County Police sign.

This reflects the multiple uses, and funding, of the building's origin. Having walked around the building, it becomes clear that it is a bizarre shape—neither square nor rectangular or even symmetrical. It is very idiosyncratic, and the outline no doubt reflects the shape of the former buildings that stood on the site and the track of the roads, i.e., Peach Street, Broad Street and Denmark Street.

52. Peach Street: The very name takes us back to the foundation of the town. The name probably derives from the de la Beche family who owned Beeches Manor. This a far more likely explanation of the name than its association with a French fisherman as in 'pêcheur'.

53. Bush Walk: Bush Walk takes its name from the Bush Hotel, which was sited here. The Bush Hotel, as well as the earliest incarnation of the Rose Hotel to which it was adjacent, were the departure and arrival points for the stagecoaches on the Windsor Forest Turnpike to pick up their customers.

54. Luckley Path: The small alleyway on the right heads off naturally enough in the direction of Luckley. This is the path of the Luckley Manor, which used to stand between what are now the Luckley House School and Ludgrove School.

55. The Redan: This is another Victorian pub dating from 1845. The Crown, the Eagle, the Good Intent, and the Welcome Inn, which were all located along Peach Street, are now all only memories. A redan, by the way, is an embarkment used as a kind of military fortification.

56. Silk Factory: Somewhere behind the modern shopfronts of Peach Street was the silk factory, anecdotally near South Place. It was built in 1771 by Thomas Cruttwell. This was probably quite a large building, at least two storeys, with a copper roof and a large chimney for the smoke from the steam engines.

Peach Street, 1926.

Peach Street, 1906.

Peach Street, 1908.

Rose Street, 1895.

The town's last blacksmith.

57. Sawmill: The silk factory was not the only industry that this side of town witnessed. During the Victorian period and through to the early part of the twentieth century, there was a sawmill at the rear of the shops in Peach Street. This area of Wokingham would have been a hive of industrial activity.

58. Church House*: Easthampstead Road leads out to Easthampstead, which was the site of a hunting lodge where Henry VII would stay. About 200 metres along the way is Church House. Church House was built as an outreach from All Saints Church. During the First World War it served as a hospital for troops shipped home from France.

59. The Old Forge: On the right is the location of the old forge. There was another smithy on the other side of town at the Hope & Anchor pub. No doubt there were others close at hand in and around the town.

60. The Overhangs*: The Overhangs were a terrace of cottages dating from the fifteenth century. To put that in perspective, that is the period of Henry VIII. Wokingham or rather Easthampstead Park has a convoluted association with Henry. Henry's father was staying at the royal hunting lodge at Easthampstead when news came that Catherine of Aragon had arrived in England. She was destined to marry Arthur, Henry VII's eldest son. Arthur and Catherine met on Finchampstead Ridges. Arthur subsequently died, and, as we know, his younger brother ended up marrying the ill-fated Spanish princess.

The Overhangs.

Broad Street, around 1900.

61. The Ship: The Ship Inn started life as a lodging house in 1745. It would have been a welcome sight to any traveller coming into town along the London Road or from Easthampstead.

62. Westende and Victoria Almshouses: Both these almshouses were demolished to make way for the new social housing. The Westende Almshouses had dated from 1451 following a bequest by John Westende.

63. Second World War pillbox: As you turn around the corner, you will see a Second World War pillbox in the corner of All Saints churchyard on London Road. The lines of defence of the pillboxes did not stretch to Wokingham. There was a concentration around Arborfield military camp, for obvious reasons, and then lines of defence to the south and east. This one was probably set up to guard the entrance to the town from the west. It is not known whether there are other pillboxes to the east, south and west of Wokingham.

64. Marker stone: Wiltshire Road is so-called because at one time this part of Wokingham was administered as if it were in Wiltshire. Up the road is Wiltshire Farm and on the corner of Rose Street is the old marker stone. This was moved from its original location on Peach Street/Cross Street when Cross Street was realigned to Wiltshire Road/Rose Street.

65. All Saints Church: It would probably not be too much to suggest that the earliest town was based around the church. On or near the site of the church was originally a pre-Norman/Anglo-Saxon chapel of ease before a church was dedicated in 1190. The current church dates from the late fourteenth century. The tower and clerestory, the upper part of the nave, were added a century later. The church fell into disrepair and was restored in 1864–66 and again in 1880. In 2020, at the time of writing, further attention is required.

66. Corner Cottage/Tudor Cottage: On the corner of Rose Street and Wiltshire Road is Tudor Cottage/Corner Cottage, which is one of the oldest houses in town. The cottages date from around 1375.

The Metropolitan, Rose Street, in 1930s, now Grasshopper Wine & Cocktail Bar.

67. Rose Street: As you enter Rose Street, it is clear that the road has been deliberately narrowed with the construction of the house in the middle of the road. The Broad Street end was similarly narrow until the 1960s when it was widened to make easier access for traffic. It is the town's oldest street and was a medieval enclosed street.

68. Listed buildings: Rose Street has thirty-two listed buildings which have been studied and researched over the years. Here are some of the highlights.

69. Dolphins the Cottage (No. 94): Early seventeenth-century cottage.

70. No. 86 Rose Street: Small late eighteenth-century house.

71. No. 82 Rose Street: Mid-sixteenth-century cottage that was extended in the seventeenth century.

72. No. 80 Rose Street: Late fifteenth-century cottage.

73. No. 78 Rose Street: Early eighteenth-century house.

74. No. 72 Rose Street: Previously an undertaker's premises where coffin measurements remain on the carriage entrance wall.

75. Paradise Cottage, the Old Bakery (Nos 68/70): Early sixteenth-century Hall house.

76. Rose Cottage (No. 65): Late sixteenth-century cottage.

77. Endon Cottage/Virginia Cottage (No. 63): Mid-eighteenth-century townhouse.

78. No. 63 Rose Street: Late sixteenth-century cottage.

79. No. 62 Rose Street: Early seventeenth-century cottage.

80. The original meaning of Rose Street or le Rothe Strete was 'clearing in the woods'. This description helps paint a picture of the Anglo-Saxon town, on the edge of Windsor Forest with a small church or chapel.

81. No. 56 Rose Street: Today this is the home to a bar called Grasshopper Wine & Cocktail Bar. For many years it was known as the Metropolitan. The building is a hall house dating to the mid-fifteenth century. Rose Street has been home to numerous pubs. In the past, there was also the Cricketers, the Bricklayers Arms, the Eagle, the Queen's Arms and the fantastically named the Poor Man's Friend, among others.

The homes of Isaiah Gadd.

82. The Small House (Nos 52–54): Around fifteenth-century hall house.

83. Nos 46, 48, and 50 Rose Street: Late fourteenth-century hall house with cross-wing.

84. Nos 40, 42, 44, and 44a Rose Street: Early sixteenth-century hall house.

85. No. 39 Rose Street: Late fifteenth-century merchant's house.

86. No. 37 Rose Street: Mid-fifteenth-century Wealden hall house and byre (cowshed).

87. Nos 36 and 38 Rose Street: Early seventeenth century.

88. Nos 35 and 35a Rose Street: Mid-fifteenth-century Wealden hall house and byre.

89. No. 34 Rose Street: Small late sixteenth-century house.

90. No. 33 Rose Street: Hall house from the late fifteenth century.

91. No. 32 Rose Street: Mid-eighteenth-century house.

92. Nos 31 and 31a Rose Street: Mid-seventeenth-century cottage. No. 31 once housed the Maiden School. The school was established in 1795 following a charitable donation by Martha Palmer. The National School located to the rear of the street was founded in 1825 by the Church of England to provide rudimentary education to the poor. The two schools were amalgamated into one a few years later.

93. Nos 27 and 29 Rose Street: This fifteenth-century building has had a variety of uses, including (from the start of the twentieth century) as a public house called The Cricketers. Subsequently in the twentieth century it was turned into a fish and chip shop.

94. No. 25 Rose Street: Mid-eighteenth-century town house.

95. No. 23 Rose Street: This was formerly The Queens Arms. The metal support for the inn sign can still be clearly seen.

96. Wesley House and St John of Epworth: Rose Street was at one time home to Isaiah Gadd's Removals and Repository business. Isaiah was a very successful businessman with many interests around the town. He was also a staunch supporter of the Wesleyan church and today, opposite the Methodist Chapel, are the houses that he built and named Wesley House and St John of Epworth. John and Charles Wesley were born in Epworth in Lincolnshire. Isaiah Gadd's initials can be seen carved just below the window on the upper storey.

97. Wesleyan Chapel, now the Methodist Church: At the far end of what is now Peach Place is the Methodist Church and the Bradbury Centre. The building was constructed in the first half of the nineteenth century.

98. No. 20 Rose Street: Arguably the oldest building in the street is probably No. 20, currently home to the WADE charity shop. The building dates from the early fourteenth century. This is the time of the Black Death or plague, the Battle of Crecy when Edward III was king, and when Geoffrey Chaucer's *Canterbury Tales* first appeared.

99. Nos 16 and 18 Rose Street: Early fifteenth-century Wealden hall house.

100. Nos 12 and 14 Rose Street: Early nineteenth century.

101. Nos 6, 8, and 10 Rose Street: Row of early seventeenth-century cottages.

102. No. 4 Rose Street: Small late fifteenth-century house.

103. Wingmore Lodge (No. 2): This mid-eighteenth-century townhouse beside Old Row Court was also owned by Isaiah Gadd. Its history is unclear, although it probably was not game keeper's lodge for Windsor Great Park and sadly no one has discovered the tunnel that reputedly led from the lodge's large cellar to Wesley House.

Wingmore Lodge.

104. The Electric Theatre: We turn back into Broad Street and the town's first cinema is just in front of us. From the front the outline of the Savoy Theatre, opened in 1913, is clearly visible. It is worth looking down the side to see the length of the building and imagine people queueing up to see the latest black and white, silent movie on a Saturday night.

105. Advertising sign: Walking along Broad Street, looking up at the houses, the sign for Pither, the butchers, can still be read.

106. Montague House*: This is one of the Georgian jewels of the town. Although the name relates to the father and son Mountague teachers from the seventeenth century and would suggest a much earlier history, the house dates from the early part of the early eighteenth century when it was home to Colonel Williamson, who died there in 1747.

107. The Elms*: The Elms was the one-time home to John Wheeler, a prominent Victorian local solicitor. His wife Ellen Maria was the aunt to Jane Hayward. She lived up the road at the Beeches Manor. The two were firm friends and would frequently visit one another's prestigious homes.

We turn back into Rectory Road to complete our short tour of the town and having noted over one hundred buildings, signs or other aspects of the not-so-secret history of Wokingham.

Selected References and Further Reading

Allington, P., Dawe, P., Hoare, B., Holland, C., King, P. (ed.), Lowe, K., Lowe, L., McLaren, J., Mitchell, C. & Watts, J. (2016) *Late Victorian Wokingham*, The Wokingham Society.

Arborfield Local History Society, Memories – The Garth Hunt. Available at: http://www.arborfieldhistory.org.uk/memories_garth.htm [Accessed 8 June 2019].

Arborfield Local History Society, The Remount Depot. Available at: http://www.arborfieldhistory.org.uk/WW1/WW1_Remount_Depot.htm [Accessed 8 June 2019].

Ayres, D., and Hunter, J. (1994) *Inns and Public Houses of Wokingham*.

Ayres, D. (1990) 'The Burninge of Okeingham', *The Wokingham Historian*, Number 2, 8–14.

Ayres, D. (1990) 'The Wokingham Bell Foundry', *The Wokingham Historian*, Number 1, 7–14.

Ayres, D. (1992) 'The War of the Roses', *Wokingham Historian*, Number 5, 7–13.

Ayres, D. (1994) 'Bull Baiting', *The Historian*, Number 7, 13–18.

Ayres, D. (1998) The Old Town Hall, *The Historian*, Volume 10, 12–24.

Ayres, D. (2001) 'Wokingham's Saxon Chapel – Fact or Fable?', *The Wokingham Historian*, Number 11, 10–12.

Baker, W. (1979) 'The Leisure Revolution in Victorian England: A Review of Recent Literature', *Journal of Sport History*, Vol. 6, No. 3, pp 76–87.

Bell, J. (2008) *St Paul's Parish Church, Wokingham*.

Bell, J. (2009) *Wokingham Remembers the Second World War*.

Bell, J. (2008) *A Stroll Through St.Paul's Parish Churchyard Wokingham*.

Bell, J. (2008) *St Paul's Parish Church, Wokingham*.

Bell, J. (2011) *A Short History of Five Wokingham Families*

Bell, J. (2014) *A Chronology of Wokingham Home Front During WW1*.

Bell, J. (2015) *A Short History of Five Wokingham Families*.

Bell, J. (2017) *A Short History of Wokingham*.

Bell, J. (2017) *Miss Baker's School and Other Wokingham Memories*

Berkshire Geoconservation Group (2019) Geology of Berkshire. Available at: https://berksgeoconservation.org.uk/geology.php [Accessed 27 May 2019].

British History Online (2015) *A History of the County of Berkshire Volume 3*, ed. P H Ditchfield and William Page (London, 1923), pp. 225–236. Available at: http://www.british-history.ac.uk/vch/berks/vol3/pp225-236 [Accessed 27 May 2019].

British Listed Buildings Available at: https://britishlistedbuildings.co.uk/101118050-the-courtyard-wokingham#.XPFgOy3Mz1s [Accessed on 31 May 2019].

Bruce, J. (Ed.) (1840) Original Letters and other documents relating to the Benefactions of William Laud. Berkshire Ashmolean Society.

Coombs, T., Sharpe, J., Davies, H., Harrison, A., and Byard, A. (2018) The Land of the Atrebates: In and around Roman Berkshire, *Berkshire Archaeological Journal*, Vol. 83.

Dils, J. (1985) *An Account of Early Victorian Wokingham*.

Ford, D. Royal Berkshire History. (Online) Available from http://www.berkshirehistory. com/bios/cduval.html Nash Ford Publishing [Accessed 24th April 2019].

Gibbs, Richard (2020) *Wokingham: A Potted History*, The History Press.

Goatley, K. (2004) *Wokingham the Town of My Life*, The Wokingham Society.

Goatley, K. (2006) *Bygone Days in Wokingham*, The Wokingham Society.

Goswell, M (1990) 'Martin's School Wokingham', Wokingham Historian, Number 2, 1 – 3.

HC Deb (1955) 'Arms Theft', *Arborfield* vol 545, cc6–8 Available at: https://api.parliament. uk/historic-hansard/written-answers/1955/oct/25/arms-theft-arborfield [Accessed 3 June 2019].

Heelas, A. T. (1928) *Historical Notes on Wokingham*.

Historic England The National Heritage List for England (NHLE) Available at: https:// historicengland.org.uk/listing/the-list/ [Accessed 2nd June 2019].

Hoare, B. (2013) *The Elms and the Ellison Family*

Hoare, B. (2013) *The Elms and the Ellison Family*.

Hosking, R. (1989) 'Wokingham Police Station'. *The Wokingham Historian*, Number 1, 19–21

Hosking, R. (1990) 'The Wellington Brewery'. *The Wokingham Historian*, Number 9, 12–26.

Lea, J., and Lea, R. (1994) 'The Holt Estate and Its Owners (part 2)'. *The Historian*, Volume 8, 25–34.

Lea, J., Goldschmied, R., and Parker, B. (Ed.) (1995) *Wokingham from Elizabeth I to Cromwell,* The Wokingham Society.

Lea, R. (1994) 'The Holt Estate and Its Owners (part 1)', *The Historian*, Volume 8, 22–31.

Must, P. (2019) *Montague House and the Mountagues*.

Nash Ford, D. (2001) 'Wokingham: A Town of Bells & Bull-Baiting', *Royal Berkshire History*. Available at: http://www.berkshirehistory.com/villages/wokingham.html [Accessed 27 May 2019].

Neave, J. (1997) *The History of All Saints Church Wokingham*.

Parliament. House of Commons (1846) Select Committee on Reading, Guildford and Reigate Railway Bill. Evidence 1846, Group 16 Vol. 26.

Roger, P. (1974) 'The Waltham Blacks and the Black Act', *The Historical Journal* Vol. 17, No. 3 (Sep.), pp. 465–486 (22 pages), Cambridge University Press.

Rosevear, A. (2004) *A booklet on the Turnpike Roads around Reading. Turnpike Roads in England & Wales*. Available at: http://turnpikes.org.uk/Reading%20turnpike%20roads. htm [Accessed 31 May 2019].

Sharnette, H. (2019) *What contribution was made by the alehouse to the life of early modern towns?*, Heather Sharnette. Available at: https://www.elizabethi.org. [Accessed 24th April 2019].

The Doomsday Book Online (1999). Available at: http://www.domesdaybook.co.uk/ berkshire.html [Accessed 27 May 2019].

Theis, J. (2001) The 'ill kill'd' Deer: Poaching and Social Order in The Merry Wives of Windsor, Jeffrey Theis. *Texas Studies in Literature and Language*, Vol. 43, No. 1, Renaissance Review (Wyatt, Spenser, Shakespeare, and Heywood) pp. 46–73.

Thompson, E. P. (1975) *Whigs and hunters: the origins of the Black Act*, Breviary Stuff Publications.

Wokingham Remembers. Available from http://www.wokinghamremembers.com [Accessed 25th January 2019].

Young, B. (1995) 'Rags to Riches – Paul Holton – The Prologue', *The Historian*, Number 8, 40–41.

Young, B. (1996) 'Rags to Riches – The Story of Paul Holton', *The Historian*, Number 9, 2–11.

Acknowledgements

The author and publisher are grateful to the following for permission to reproduce material and photographs that appear in the text.

Jim Bell for providing access to the Goatley Collection Images, NetXposure.Net and Vin Miles for providing access to his collection.

The Royal Academy of Arts for the painting by James Smith *c.* 1739 of *The Seat of the Hon. Colonel Williamson at Oakingham* on page 22.

National Library of Scotland for permission to reproduce the Ordnance Survey map image on page 14.

Public domain on page 47 is sourced from WikiCommons. It is available from http://www.britishmuseum.org/research/collection_online/collection_object_details. aspx?assetId=963915001&objectId=1544567&partId=1

The painting of Claude Duval painting by William Powell Frith is a public domain image and is sourced from from WikiCommons. at www.allartpainting.com. The appropriate licence can be accessed https://commons.wikimedia.org/wiki/Commons:GNU_Free_Documentation_License,_version_1.2. These images are available on the internet and are included in accordance with Title 17 U.S.C. Section 107.

The Victorian Picture Library on page 15 and finally Wokingham Town Council for providing access and enabling usage of painting on pages 31 and 40.

While the author has made every effort to identify, trace and credit the owners of copyright, he is happy to rectify any errors or omissions in further editions.